vol.1

international
panorama

Landmarks for the Future

by Luca Maria Francesco Fabris
Milan Polytechnic and Beijing University of Architecture and Engineering "Haiju" Expert

This new project by THE PLAN follows on from the success of the Italian Panorama series, which for several years now has published a large collection of the most noteworthy architectural works being achieved in Italy today. The new series now widens its horizons to take in the world with an anthology of projects whose design, technology and overall solutions sum up our complex contemporary times. For it is now evident, some 20 years into the third millennium, that there are no longer clearly identifiable schools of thought of the kind that once triggered revolutions: clearly identifiable approaches to architectural projects underpinned by an equally vigorous philosophical discourse.

Looking back over the last century, for example, we see how every 20 years or so, sometimes even earlier, a different architectural dogma appeared, a new "ism" - rationalism, internationalism, brutalism, regionalism, postmodernism, or deconstructivism - which although initially rooted in abstract considerations soon became part of the built world, changing the forms of our urban fabric and consequently our daily lives. A century ago, there were "Maestros" with a capital M, celebrated names whose lectures and works steered the course of architecture, iconic luminaries whose indications were unerringly adhered to by hordes of followers. In the last 20 years we can be sure of one thing: we live in a globalized world where there are only trends. In our liquid interconnected world, the speed and amount of information received make in-depth reflection impossible. Ours is no longer a time for thinkers. Ours is a time of influencers who can launch a new trend with a tweet. We no longer have "Maestros", only archistars, often acclaimed by the media for delivering their single overarching solution for man's habitation needs wherever in the world. Ours is an all-encompassing planetary culture, swiftly delivered, superficial and heedless of different cultures, places and natural cycles.

Yet it would be too glib to describe everything built in recent years as cookie-cutter anonymous. Even in this mobile voluble period of ours, many buildings testify to architects determined to adopt different approaches as they apply technological and construction know-how, innovative materials, cultural rediscovery, environmental awareness and adaptive ability. This contemporary architecture reinstates dignity and beauty in the profession, and is the subject of this volume.

Austria is often the source of innovative architecture, becoming the purveyor of new ideas as it reassesses rooted tradition. The Unterdorf elementary school in the region of Vorarlberg is the architectural product of new thinking in education that has given rise to a new schoolhouse model based on functional activity clusters rather than a series of classrooms. Designed by Dietrich | Untertrifaller Architekten, the school is built entirely of timber, creating a warm natural embrace both inside and out. The result is a vibrant open architecture, at the same time experimental and logical.

One of today's most promising construction technologies involves Cross Laminated Timber (CLT) panels. The Finnish firm OOPEAA completed an interesting pilot project of a residential quarter in Jyväskylä, Finland, where all frames - beams and columns - are CLT components into which prefabricated

modular infills have been inserted. Each apartment comprises a wet area - kitchen and bathroom - and a dry zone - bedrooms and living room. With its excellent sustainability parameters, reduced costs and rapid construction, engineered timber - which can also be used for high-rise buildings - will become of major importance in the near future.

Messner House by noa* network of architecture can be likened to a conjuring trick: from the outside, it appears to conform to the vernacular architecture of the Siusi Valley, Italy; from the inside, it becomes a place in which different size areas follow a mountain trail to reach a solitary peak. The imposing timber frame supports several dwelling units that fluctuate in a common open space. The unique interior is hardly visible from outside, only a few things giving some clues. Here, tradition prompts innovation to take on a timeless dimension.

Once empty and abandoned, the old post office of 1885 in Cambridge, Canada, has now been given a new lease of life as a multimedia center with this vibrant project by RDHA. The heritage building has now been encased in a system of glass and steel boxes providing new, naturally lit spaces. The complex is now a place for meeting others along a continuous pathway that opens onto a series of environments, some in the old building, others in the new section but all imbued with a welcoming communicative feel. This is how a place for study, socialization or relaxation can become a building that embodies the spirit of a whole community.

The Engineering Education and Research Center (EERC) at The University of Texas at Austin by Ennead Architects with Jacobs shows how sustainable building can go hand in hand with top-drawer research and learning spaces. The two tall wings of this large LEED Silver certified complex contain laboratories, lecture halls and teaching spaces for the two levels of higher education while an enormous interior plaza serves as a common meeting place for all occupants. The locally-sourced limestone and metal of the EERC's elevations contrast with the glazing and steel of the large covered gallery from where all the learning and research spaces are accessed with symbolic ease.

This fascinating residential project by Wendell Burnette Architects in Cave Creek (Arizona, USA) a short distance from Phoenix cleverly hides its technological prowess, creating a building that exudes a mysteriously suspended narrative. In reality, the construction is practically a zero-emission achievement. There is a rainwater collection system, and the solar panels concealed in the roof release or store heat accumulated in the elements making up the living area. Just as wealth should never be paraded, nor in the near future will sustainable technology.

Eleven different sized exhibition rooms set around an artificial pond make up the extension to the Glenstone Museum in Potomac, Maryland, USA. They rise from the earth as if obeying some unexpressed yet gentle, almost musical, logic. The museum walls have been created by putting cast-concrete blocks one on top of the other - all the same yet each an individual piece. Between the walls are gigantic windows in slender, almost invisible, steel frames. While

everything in this admirable project by Thomas Phifer speaks of the imposing force of matter, what shines through is the poetry. And then there is the light. An exemplar of many contemporary architectural briefs, this 19th Century building in Rome was given a new lease of life with a contemporary functional makeover. Charged with the restoration, the architecture firm It's employed BIM technology in all phases of the project, from concept through to the worksite. As well as allowing recovery of the original structural dimension of the heritage building, BIM permitted the inclusion of innovative elements and materials combining aesthetic and functional excellence, like the use of reflective steel and Carrara marble to create luminous interiors for the Confcooper Headquarters. Ancient crafts and new technology here make for contemporary excellence.

We are now familiar with the fact that the close relationship between nature and architecture always present in the work of Sandy Attia and Mattia Scagnol, MoDusArchitects, is never the same, never formulaic. Their architecture is always carefully designed to fit into the landscape but never to be completely enveloped by it. This tourist information center in Brixen, Italy, was constructed with the idea of protecting a centuries old plane tree. Or perhaps, it is the plane tree that sustains the building, leaning over it to create a covered public space. Lightness and solidity are here successfully juxtaposed in a formal experiment that makes the building much more than just a service-providing utility.

Stephan Chevalier and Sergio Morales have reinterpreted a deconsecrated Gothic-revival church in Old Quebec, Canada, brilliantly transforming the structure into a library where readers and writers can meet. This former place of worship is now a fully accessible open space since all the technical functions have been placed in a new external brass-clad annex. Contrasting materiality and functional distribution circuits are the paradigms of intelligent restoration and refurbishment blending ancient and modern.

Like all their architecture, the project by Brooks+Scarpa is the result of study into how form and function should be combined to suit the particular location with its particular features. The plastic curves of the continuous white surface of the Southern Utah Museum of Art recall the canyons on the outskirts of Cedar City, Utah, USA. A huge north-facing glazed curtain wall floods the exhibition space with natural light while the enormous roof cantilever creates a protected place for socialization, its geological aspect the result of a clever combination of parametric design and architectural flair.

This retrofit project became a declaration of intent for the whole Engineering Quad of Cornell University in Ithaca, New York. In their restructuring project of the 1956 international-style Upson Hall, LTL Architects and Perkins & Will salvaged only the original concrete structure, which became the frame for a series of contemporary lecture halls, labs and communal spaces linked by distribution systems that often also serve as socialization areas. Pierced by amply framed thermally efficient openings, the handsome modular terracotta-clad façade with its rhythmic succession of lights protects the

interiors from solar gain and complies with strict sustainability criteria. Making architecture an organic component of its setting is the key concept underpinning this project by Mino Caggiula Architects for the studio-home of artist Alice Trepp in Origlio, Switzerland. Contemporary Ticino architecture has been revisited and blended with its location, becoming part of the natural landscape. The decisive materiality of concrete takes on an airy lightness as the structure's curving frame, emerging from the earth to blend with its surroundings in a complex play of levels, water and shifting light and shade. This is visionary architecture that dialogues expertly its location and its times. Michel da Costa Gonçalves (DROO) and Nathalie Rozencwajg (NAME) under RARE Architecture showed how to intervene decisively on historic architecture combining respect for the legacy of the past with boldly innovative thinking. Their transformation of the old Town Hall of the London borough of Bethnal Green into a luxury hotel has made clever use of the listed building's original spaces to which has been added an extension of a new top floor and wing that disappear behind an origami-patterned aluminum skin. As well as ensuring insulation and concealing the building's plant and equipment, the new parametric overlayer creates a stimulating contrast between old and new.

Not everyone would feel up to competing with the magnificent work of Lluís Domènech i Montaner. Benedetta Tagliabue took up the challenge with enviable natural ease, as if she instinctively knew what to do. The result is a delightful building, a contemporary setting that becomes the backdrop against which to show the past in a refreshing new way. Barcelona's Kálida Sant Pau Centre is a triumph of *virtuoso* volutes of terracotta resembling lacework and sinuous organic walls. Tagliabue has created an enveloping space, a small miracle to be studied and understood through the senses.

The relationship created between the landscape and architecture can give rise to manmade jewels exalting the beauty of Nature. Designed by sacher.locicero.architects, the Ruhewald Chapel near the Castle of Tambach, close to Weitramsdorf, Germany is just such a creation. This small place of worship gives neo-Gothic form to the Vitruvian Golden Ratio, creating a space that both transcends our normal references yet is part of what we recognize. Pointed glulam arches, an outer skin of bark shingles, glazing and an auspicious copper door combine technology and tradition to create a timeless yet highly relevant architecture.

A major landmark in the history of mankind, Byblos (locally Jbeil, Lebanon), is today a modern university city. Atelier Pagnamenta Torriani, A·PT, have designed the new American University library, combining sensitivity for the location with the demands of building sustainability to LEED Platinum standards. To achieve this, the two volumes making up the new library have made modern use of many traditional local architectural features: double skin façades, passive ventilation, and a water collection and recycling system. Gently rotated, the two structures converge to create a small plaza where the different cultures making up the city converge, as they always have.

Unterdorf Elementary School
Höchst, Austria

The typical cluster model of modern school architecture springs from the belief that learning should be an enjoyable participative activity carried out in small groups in flexible, diverse and preferably outdoor spaces. Each space in the cluster model has a specific identity linked to its location and connection to the whole. The different environments are positioned not just in terms of physical characteristics such as orientation and usability, but also take into account perceptive and psychological aspects.

Designed by Dietrich | Untertrifaller Architekten, the Unterdorf elementary school in the Austrian town of Höchst, in the region of Vorarlberg, is an exemplar of the cluster type school.

Right from the outset when preparing their submission to the competition, the architects involved teachers, community representatives and consultants. Not only a key factor helping the project to win the contest, this led to a project that has set a new standard for schools in Austria.

Starting with the layout of the outdoor areas, it is clear that the concept of integrating children into the community is one of the cornerstones of the project. This is evident at different levels, first with the harmonious integration of the school building itself into its urban setting, a low-density community of single-family houses. In addition, the school playground in front of the auditorium is connected to Unterdorf's network of pathways and local residents can make free use of the school grounds and sports facilities.

The building itself is an elegant linear single-story structure, its rectangular plan is divided by a long central corridor. On the west side lie a large entrance hall serving as an auditorium, special activities classrooms, offices and a double height gym, this latter reached by a staircase down to a below level entrance. Moving partitions can cut off the auditorium from the rest of the school to create a community space for events such as conferences hosting up to 120 people. In addition, the gym has a separate entrance allowing its use by local sports clubs out of school hours.

On the east side of the central corridor, four identical clusters host two classrooms, a community area, relaxation room, toilets and changing rooms, all distributed around a luminous multifunctional environment with a raised roof and large skylight. From here, pupils can directly access the private garden and open-air classroom.

All the rooms in the school are separated from one another by large glazed partitions, ensuring constant teacher supervision even when pupils are studying or playing in different rooms.

A constant incentive to make use of all available spaces, this visual connection also reinforces a sense of community, both in the whole school and in each cluster.

The entire building is made of unclad wood. Not only allowing considerable energy savings and a comfortable, welcoming atmosphere for all occupants, timber has the added advantage of prefabrication and so, swift construction - a fundamental requirement for school buildings where construction is bound by timelines dictated by the school year, and therefore often limited to the summer holidays.

■ Ground floor plan - Scale 1:1000

■ Cross section - Scale 1:500

■ North elevation - Scale 1:300

South elevation - Scale 1:300

■ East elevation - Scale 1:300

014

■ West elevation - Scale 1:300

015

■ Axonometric view of the exclusively
timber frame - Not to scale

CREDITS

Location: Höchst, Austria
Client: Municipality of Höchst
Completion: 2017
Gross Floor Area: 2,530 m²
Cost of Construction: 9,045,586 Euros
Architect: Dietrich | Untertrifaller Architekten
Project Management: Peter Nussbaumer
Construction Management: gbd

Consultants
Electrical: Hecht
Timber Structure: merz kley partner
Concrete Structure: Gehrer
Building Physics: Weithas
Services Engineering: E-Plus
Landscape: Heinrich

Photography by Bruno Klomfar
Courtesy of Dietrich | Untertrifaller Architekten

Puukuokka Residential Complex
Jyväskylä, Finland

Designed by OOPEAA, the Puukuokka residential complex consists of three all-wooden condominiums six and eight-stories tall. Located in Kuokkala, a suburb of Jyväskylä, in the picturesque region of the Finnish Lakeland, it was commissioned by Lakea and executed in partnership with the Stora Enso company and the town of Jyväskylä. The project highlights the town's links with the surrounding natural hills and lake. Alongside the adjacent Kuokkala Church - another OOPEAA design from 2010 - it has become a focal point in the neighborhood.

Completed in 2015, Puukuokka One was the first eight-story timber-framed apartment building ever erected in Finland. Puukuokka Two was completed in 2017 while Puukuokka Three went up in August 2018. The whole complex offers 184 apartments for single inhabitants, couples of all ages and families with children.

Built on a concrete base, each building offers residents basement parking bays. To preserve the natural surrounding hilly landscape and minimizing disturbance to the underlying rock substrate and existing plantlife, the buildings follow the site's contours in a project that explores all of the potential prefabricated modular glulam construction has to offer to make high-quality, environmentally-friendly and economical housing.

From the earliest design phase, the firm sought a solution to fully leverage Cross Laminated Timber (CLT)'s technical and aesthetic qualities and put up a building with its own distinct architectural identity. The design concept also sought to combine the warmth and privacy of single-family homes with the semi-public character of a condominium's shared spaces.

Puukuokka Complex was a pilot project for developing and testing a CLT technology-based modular construction system. Each apartment consists of two prefabricated modules: one for the living room, balcony and bedroom, the other housing for the bathroom, kitchen and atrium. The buildings' façade elements, also entirely wooden, were made separately and brought to the site as prefabricated modules for assembly. Manufacturing them in a local factory less than two hours away from the site made it possible to limit the materials' exposure to atmospheric agents, ensuring particularly high-end quality. Building with prefabricated modules also made it possible to reduce site construction time by up to six months for each building.

Employing this construction system made it possible to create a spacious distribution corridor and a very bright full-height atrium, with carefully framed views opening to the surrounding forest landscape. Corridors and the atriums are energy-efficient semi-heated filter spaces. The insulating qualities of wood allow for independent temperature control in individual units, while dry technology integrates heating, water, electricity and ventilation systems into the corridor walls, leaving them easily accessible for maintenance.

The project was a trailblazer for innovative rental financing strategy too. In order to support local society and stable communities, all that was required was a 7% down-payment on the purchase price to get a state-guaranteed loan that, after a 20-year rental period, results in full ownership of the unit. Puukuokka's dwellings have won high praise from residents, who enjoy the comfortable living environment with excellent facilities in a socially-stable neighborhood.

■ Site plan - Scale 1:1000

■ Axonometric diagram of the prefabricated building parts composing the Puukuokka buildings

1- Wall for technical installations
2- CLT module of kitchen and bathroom units
3- CLT module of living room and bedroom units
4- Façade system with window frames
5- Balcony with CLT structure
6- Corridor with CLT slab
7- Vertical connections in CLT

■ Exploded axonometric view showing modular elements

■ Exploded axonometric view of the program showing main functions

1- Building 1
2- Building 2
3- Building 3
4- Access level
5- Basement level and cellars

■ 1st Floor plan - Scale 1:700

Cross section - Scale 1:700

CREDITS

Location: Jyväskylä, Finland
Client: Lakea
Completion: 2018
Gross Floor Area: 18,650 m²
Architect: OOPEAA
Principal Designer: Anssi Lassila
Project Architect: Juha Pakkala,
Iida Hedberg, Jussi-Pekka Vesala
Design Team: Teemu Leppälä,
Mia Salonen, Teemu Hirvilammi,
Hanna-Kaarina Heikkilä, Santtu Hyvärinen
Landscape Design: VSU Landscape Architects

Consultants
Building Technology and HVAC:
Insinööritoimisto Koski-Konsultit
Fire System and Safety: KK-palokonsultti,
Firecon Group
Concrete Structure: Insinööritoimisto Pertti Ruuskanen
Timber Structure: Lauri Lepomäki / SWECO
for Puukuokka One and Toni Kekki /
A-Insinöörit for Puukuokka Two and Three
Electrical: Sähkösuunnittelu J.Nenonen

Photography by Mikko Auerniitty
(pp. 018, 023, 025, 026, 027)
and Toni Kekki (p. 021)
Courtesy of OOPEAA

Messner House
Siusi allo Sciliar, Bolzano, Italy

In the center of Siusi allo Sciliar, against the naturalistic backdrop of the Alpe di Siusi mountains in Italy's South Tyrol region, Messner House is an astonishing project. Inside an envelope faithful to local building traditions, it deploys free, playful spatiality to re-embody the desires and memories of the client, who in this case happens to also be the designer.

Stefan Rier, who with Luka Rungger founded noa* network of architecture, was inspired for these spaces by his childhood memories of growing up amid mountain architecture, playing in barns, launching himself into the air, exploring the dynamic and vertical spatiality evidently reflected here, in the design for his home.

"We dressed the outside of the building in a traditional 'costume': a grille of wood that surrounds it on all sides, just like an old Alpine barn. For the inside, I left tradition behind and freed myself from constraints and pre-established patterns. It was an exercise in looking forwards - as well as a tad backwards - to my fabulous childhood".

In keeping with typical traditional rural construction, the house rises three floors on a stone base, its larch wood structure culminating in a double-pitched roof. Externally, the completely wood-covered volume fits in with the typical morphology of an alpine barn, facing north onto the road with a closed if articulated elevation.

The wooden structure is visible over its full 12-m height, defining a space that looks like a fluid and open whole; within, three bedrooms are conceived as suspended "boxes", autonomous volumes inserted between the structural interweave, partially interrupting the free flow of the space.

The interior "revolution" in type and distribution - even the bathrooms are openly visible, without walls or visual screens - unfolds in the form of stylistic and material cross-pollination. Wood and stone of South Tyrolean tradition combine with resin, ceramics in Mediterranean tones, a finely-wrought iron staircase carved in Arabic style, and curtains dotted around to define spaces in dynamic, theatrical configurations.

Conceived as a wide-open space, privacy levels increase from the ground floor up. On the topmost level, a volume houses a sauna that looks out over the landscape through a full-length glass wall. Last but not least, light plays a key role in the project. Natural light illuminates the interior through the south façade, which is glazed throughout and opens out onto the garden and surrounding landscape, partially filtered by an external wooden grille mounted about 2.5 m from the elevation; from the roof, an east-facing skylight brings additional natural light to the interior.

■ Cutaway axonometric views. Bedrooms and sauna
are suspended in the large full-height interior
Not to scale

1- Living area
2- Dining area
3- Kitchen
4- Laundry
5- Bedroom
6- Walk-in closet
7- Library

■ XX Section - Scale 1:400

■ YY Section - Scale 1:400

035

■ South elevation - Scale 1:400

■ East elevation - Scale 1:400

036

CREDITS

Location: Siusi allo Sciliar, Bolzano, Italy
Client and Lead Designer: Stefan Rier
Completion: 2017
Gross Floor Area: 220 m²
Architect and Interior Design: noa* network of architecture

Photography by Alex Filz
Courtesy of noa* network of architecture

Idea Exchange Old Post Office
Cambridge, Ontario, Canada

Owned by Idea Exchange, the former post office in Cambridge, Ontario, now offers residents free access to a full range of learning and creativity spaces as well as a new meeting and socialization hub. Anchored to the bank of the Grand River, the former post office was extended and restructured by RDHA. The renovation of the original building dating back to 1885 has added a 83-sq. m pavilion that both wraps around the existing structure and cantilevers over the water. Its completely glazed skin reveals the activities going on inside, welcoming in passersby.

The new Idea Exchange Old Post Office is a source of considerable civic pride for Cambridge, the transition from post office to digital hub signaling this small city's ability to keep abreast of communication technology with the concomitant transformation in 2015 of its library system, renamed "Idea Exchange".

A glass box vestibule introduces visitors into the foyer from where a staircase leads to the contemporary volume projecting over the river. Continuing around the first floor of the old masonry post office, it offers occupants a close-up of the immaculately restored stonework as well as exclusive views of the river and beyond. The windows of the old building have been turned into entrances to the restaurant and a comfortable multifunction room. Openings in the floor allow natural light from skylights overhead to flood into the below-level floor, at the same time creating visual connection with activities going on in the heart of the building.

Great attention has been given to the smallest detail. The stone patterns on the historic building façade prompted the ceramic frit pattern of the glazing as well as both the perforation pattern of the timber panels covering the heating system and the perforated drywall, which, as well as creating visual uniformity with the ceilings, is also an efficient sound dampener. The below-grade level is now a suite of different studio spaces: a theater, film and audio recording studio, and laptop dispensing and gaming areas. Musical instruments are also available for recording and practice. The children's Discovery Center on the second level occupies a single large light-filled room with smart tables, robot construction kits and built-in feature walls with Lego, Lite Brite and magnets.

This level gives access to the large outdoor rooftop terrace and green roof overlooking the river, with more interesting close-up views of the historic building and recently restored slate roof. Above the terrace is a contemporary floating glass block. Accessible from the attic, this is now the boardroom. The attic itself is a small, completely white space whose sharply peaked ceiling is supported by an elegant star-shaped array of steel rafters, now adapted to contain strip lighting. The architects have turned the attic into a fully equipped "maker-space", for ingenious creative work, equipping the area with a laser cutter, 3D printer, soldering stations, vinyl cutters, irons, sewing machines and wood- and metal-working tools. Another attraction is the view through the glazed ceiling up to the tower clock with unimpeded views of the weights and gears in action.

Another interesting project detail was designed with the future in mind. Knowing that a river walk was planned along the river edge passing under the projecting glazed volume, the architects clad the soffit of the overhang with mirror-finish aluminum panels, emphasizing the building's relationship with its setting and giving future walkers a reason to look up.

■ Site plan - Scale 1:300

1- Existing building
2- Addition
3- Grand River
4- Neighboring properties
5- Future river walk
6- Water street sidewalk
7- Entry plaza
8- Existing heritage gates

■ Study sketch in plan

■ Axonometric view showing
different functional divisions

▢ Atrium / entry atrium	▢ Link
▢ Attic maker-space	▢ Meeting room
▢ Children's Discovery Centre	▢ Restaurant
▢ Elevator / stair	▢ Teen studios
▢ Library café	

041

■ Ground floor plan - Scale 1:300

1- Atrium
2- Office
3- Server room
4- Cistern
5- Staff work area
6- Storage area
7- Recording room
8- Performance space
9- Mechanical - electrical room
10- Fridge - freezer area
11- Staff lounge
12- Entry vestibule
13- Entry foyer
14- Display area
15- Staff check point
16- Library reading area
17- Restaurant seating
18- Restaurant kitchen - café
19- After hours entry
20- Heritage exit vestibule

■ 1st Floor plan - Scale 1:300

15

14

17

13

18

12

19

16

20

■ XX Section - Scale 1:300

■ North elevation - Scale 1:300

044

■ East elevation - Scale 1:300

046

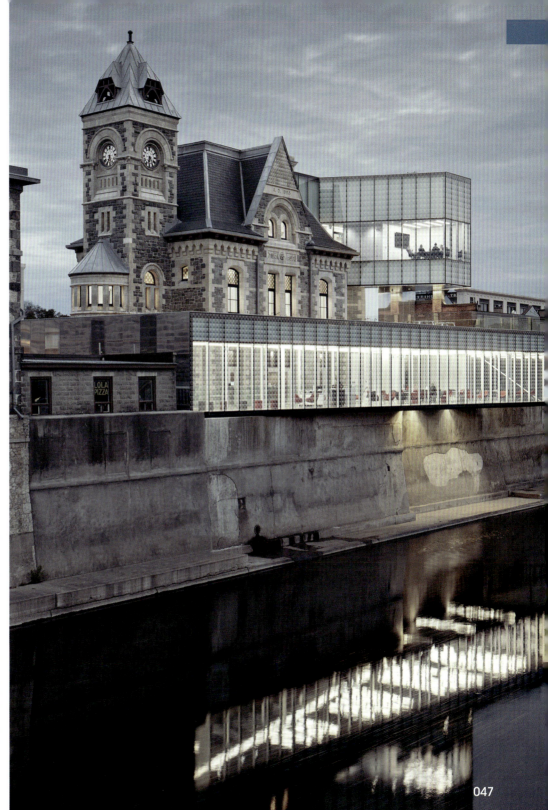

CREDITS

Location: Cambridge, Ontario, Canada
Clients: City of Cambridge, Idea Exchange
Completion: 2018
Gross Floor Area: 1,736 m²
Costs: 7,267,973.59 Euros
Architect: RDHA
Design Principals: Bob Goyeche, Tyler Sharp
Project Managers: Juan Cabellero, Ivan Ilic
Design Team: Soo-Jin Rim, Gladys Cheung, Andrew Cranford
Main Contractor: Collaborative Structures

Consultants
Heritage: Stevens Burgess Architects, Kelly Gilbride
Structural: WSP, Andrew Dionne
Mechanical and Electrical: Jain & Associates
Landscape: NAK Design Strategies, Robert Ng
Civil: Valdor Engineering, David Guigovaz
Cost Estimator: AW Hooker Associates
Acoustics: Aercoustics Engineering

Suspended Ceilings: Armstrong Ceilings
Drywall: Knauf
Aluminum Panels: Mitsubishi

Photography by Tom Arban
(pp. 038, 040, 042, 043, 044, 045, 046, 047)
and RDHA - Sanjay Chauhan (p. 041)
Courtesy of RDHA

Engineering Education and Research Center at The University of Texas at Austin

Texas, USA

Designed by Ennead Architects in partnership with Jacobs, the Engineering Education and Research Center (EERC) is a new 40,227 sq. m multidisciplinary teaching and research facility and the latest addition to The Cockrell School of Engineering at The University of Texas at Austin.

Taking over seven years to complete, the EERC embodies a new approach to engineering training, integrating project-based undergraduate study with interdisciplinary graduate research. As well as state-of-the-art classrooms, generously proportioned labs and maker-spaces, the new building also contains: the 2,137 sq. m National Instruments Student Project Center, making available to undergraduates the most advanced engineering research tools; the James J. and Miriam B. Mulva Auditorium and Conference Center, Cockrell School's largest events space; and Texas Instruments' teaching and project labs and Innovation Center, the school's first space dedicated to entrepreneurship, facilitating the swift transition to the market of revolutionary ideas coming out of the school.

The two, 9-story limestone and glass towers acknowledge the substantially different requirements of the labs, offices and workspaces of the Department of Electrical and Computer Engineering and interdisciplinary graduate research. The two towers and their inwardly oriented glass curtain wall façades are connected at ground level by a 3-story, glazed-ceiling atrium that serves as a light-filled public space. This is the building's social hub, designed to facilitate "productive collisions" between faculty, staff, student and visitors. From here, bridges and a large spiral staircase provide distribution circuits throughout the volume and connect the different research environments. Clearly visible through the north wall glazing is the National Instruments Student Project Center - a raw concrete volume whose mechanical plant and equipment have been left unconcealed - dedicated to project-based interdisciplinary learning.

The EERC neutralizes the site's 9,15-m grade change across to Waller Creek with new campus connections and access routes. The contemporary language with which the building blends into its setting with shaded walkways, green areas and the entrance staircase nonetheless references features of the historic campus. Likewise, the construction materials - local limestone, stainless steel and zinc - echo the other campus buildings.

Certified a LEED Silver building for its energy-efficient performance, the complex boasts optimal solar orientation along with a sophisticated customized sun-shading system designed on the back of location-specific studies to establish maximum natural lighting and occupant comfort while minimizing heat gain. The building also has automated air-quality sensors regulating air exchange rates in the labs, storm-water collection and green roofs, which in the intense Texan heat help reduce building heat load.

Recognizing the extent to which innovation is generated by a wealth of different inputs and perspectives, the EERC has been designed above all as a stimulating learning space allowing unimpeded collaboration among future engineering-sector leaders.

■ Site plan
The building in its urban University of Texas
campus setting - Not to scale

■ Study model

1 INDEPENDENT RESEARCH
NEIGHBORHOODS

2 INTERCONNECT

3 ACTIVATE

■ Study diagram of distribution links

■ Solar exposure over the year

March
79° Average high / 58° Average low

June
94° Average high / 55° Average low

■ Cutaway perspective view - Not to scale

September
81° Average high / 59° Average low

December
63° Average high / 42° Average low

■ Ground floor plan - Scale 1:1000

■ 3rd Floor plan - Scale 1:1000

■ Cross section - Scale 1:1000

CREDITS

Location: Austin, Texas, USA
Completion: 2017
Gross Floor Area: 131,826 m²
Design Architect: Ennead Architects
Executive Architect: Jacobs

Consultants
Structural: Datum + Gojer Engineers
Electrical and Mechanical: Affiliated Engineers
Civil and Cost Estimator: Jacobs
Landscape: Coleman & Associates
Graphic Design: Jankedesign
Audio-visual Equipment: Datacom Design Group

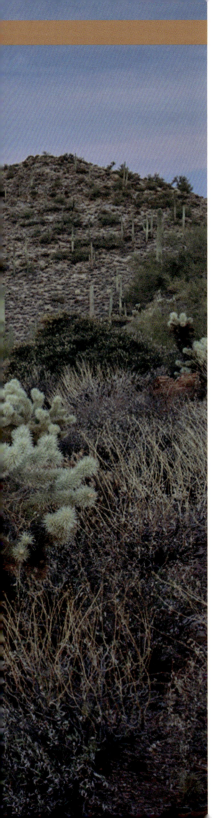

Hidden Valley Desert House
Cave Creek, Arizona, USA

Arizona, a state in the south-west of the United States of America, is characterized by a rocky, desert landscape dotted with many succulent plants, some of which are cacti. Most of the territory is made up of mountains or plateaus, even though the Colorado River's Grand Canyon is the first image that comes to mind when many think not just of Arizona but of the USA.

The arid landscape and warm colors inspired the Hidden Valley Desert House, designed by Wendell Burnette Architects, an international architecture firm based in Arizona renowned for its skill in adapting architectural forms to place and surrounding environments. The architects adopt a creative approach to create spaces that are involving for the people who reside there.

The Hidden Valley Desert House is located at the midpoint of a small hill studded with cactus plants, high enough up for views out over the Phoenix Valley and its spectacular sunsets. Well-anchored to the rock on a solid base, the building is topped by a large structural canopy roof. This cantilevered extension offers excellent shelter from the intense desert sun, as well as capturing direct radiation for energy and rainwater too, making the house a very close to zero-consumption dwelling.

Around the top of the building, the perimeter features a strip of large mill finish stainless steel sheeting that reflects sunlight and protects the photovoltaic panels installed on the flat roof. The core of the house is a central section where the walls are designed to keep the glass-to-wall surface ratio low, while allowing plenty of scope to admire the surrounding landscape. The cave-like ground floor is topped with a first floor that is open in every direction, often unimpeded by any architectural element that might clearly mark the passage between inside and outside.

The 186-sq. m living level is connected via the canopy roof to a broad, 93 sq. m veranda overlooking a promontory.

The entire structure rests on a base composed of elements from different materials: stepped reinforced concrete, masonry for the walls, and a slab of colored concrete rendered monolithic by the application of a uniform layer of plaster.

The underside of the canopy - both inside and outside - is a black theatrical fabric scrim that creates a continuous feeling of deep soft shade. The interior color scheme is dominated by black too, arousing a sense of unbroken shade achieved by using cold-rolled steel cladding, MDF wood, three different types of highly-sustainable resin-infused dark finish paper, and purple-black stucco with vermiculite that adheres to the Japanese concept of Wabi-Sabi (in which imperfections are considered an important aesthetic element). The perimeter is skirted by an artificial brook that instills tranquility and well-being. The interiors were meticulously designed in every detail; in perfect harmony with the architecture, the furniture is minimalist and essential.

■ Exploded perspective view - Not to scale

Canopy

Dispersed core

Plinth

■ 2nd Level plan
 Scale 1:250

1- Entrance
2- Outdoor dining area
3- Kitchen
4- Dining room
5- Living room
6- Relax area
7- Pantry
8- Laundry
9- Walk-in Wardrobe
10- Bedroom
11- Meditation room
12- Studio
13- Patio
14- Gym
15- Garage

062

■ 1ˢᵗ Level plan
Scale 1:250

12

13 14 15

■ XX Section - Scale 1:250

■ YY Section - Scale 1:250

065

■ South elevation - Scale 1:250

■ North elevation - Scale 1:250

066

CREDITS

Location: Cave Creek, Arizona, USA
Client: Kim and Keith Meredith
Costs: 1,152,840 Euros
Architect: Wendell Burnette Architects
Project Team: Wendell Burnette, Qianyi Ye,
Austin Nikkel, Rebecca Gillogly, Trevor Kowal
Main Contractor: Verge Design Build
(Joby Dutton, Mike Alexander)

Consultants
Structural: Rudow + Berry
Mechanical and Plumbing: Otterbein Engineering
Electrical: Woodward Engineering
Lighting: Creative Design in Lighting
Civil: SSE

Sanitary Ware: Duravit

Photography by Bill Timmerman
Courtesy of Wendell Burnette Architects

The Pavilions at Glenstone Museum
Potomac, Maryland, USA

Completely immersed in a vast parkland, the Glenstone Museum, northwest of Washington, DC, has become America's largest private museum. The museum sets out to seamlessly integrate art, architecture and landscape, the enhancing the experience of art with enjoyment of the distinctive architecture and the pleasure of wandering through the 93-ha wooded campus dotted with works of art.

To increase its offerings accessible to the public, Glenstone recently underwent major expansion of its museum facilities and landscape. Designed by Thomas Phifer of Thomas Phifer and Partners, the new 18,952 sq. m architectural complex, known as The Pavilions, includes a suite of customized galleries dedicated to individual artists as well as new offices and storage spaces. Fitting effortlessly into the landscape, the volumes appear as stone outcrops in the sloping terrain. Organized in a loose rectangle and providing a circular visitors' route, The Pavilions cluster around a large pond containing many species of aquatic plants.

The eleven new rooms are of different sizes, layouts and lighting conditions, providing artists with personalized backdrops for their installations. Natural light is a key design feature throughout. Most rooms are illuminated by large openings and skylights, the natural light preempting the need for artificial lighting. One exhibition area has even been left completely roofless, open to the elements to allow the changing light and shadow of the passing seasons to reveal and conceal details of the artwork exhibited.

The Pavilions are made of 26,000 individually cast concrete blocks, each 1.8 m long, 0.3 m high, and 0.3 m deep. Their surface color was obtained not by adding pigments but simply by mixing the cement and sand in varying conditions on different days. The striking materiality of the elevations is offset by extensive transparent glass panels in stainless steel frames. Inside, light concrete and light maple walls create a neutral setting that does not distract from the artworks on display. As well as adding a new exhibition space, the expansion includes a new visitors' entrance, two cafés, and a center showing the environmentally sustainable landscape interventions undertaken by Glenstone. This in fact led the museum to subscribe to the LEED New Construction protocols. As well as major energy-saving measures, the designers have placed two thirds of the new buildings underground to exploit the natural geothermal properties of the land together with constant natural air circulation. There is also a storm water recovery system on the roof, half of whose surface area is planted with natural vegetation.

Entry plan - Scale 1:1500

Galleries plan - Scale 1:1500

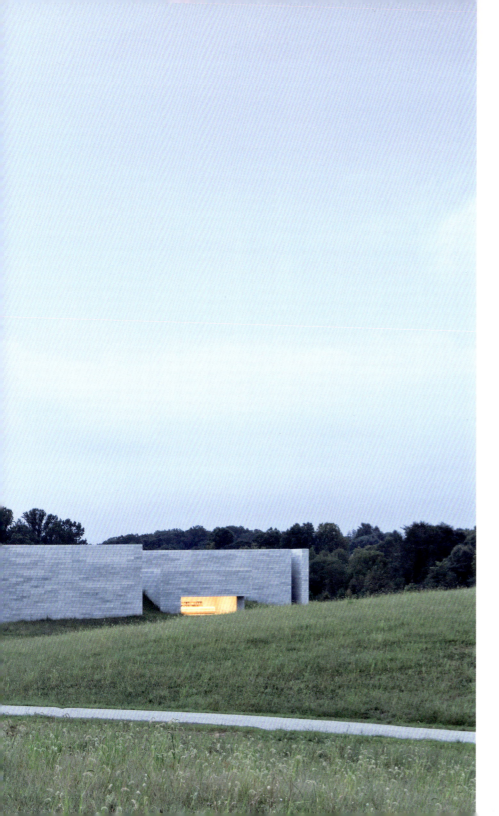

CREDITS

Location: Potomac, Maryland, USA
Opened to the Public: 2018
Gross Floor Area: 18,952 m²
Cost: 172,500,000 Euros
Architect: Thomas Phifer and Partners
Design Team: Thomas Phifer, Gabriel Smith, Andrew Mazor, Michael Trudeau, Rebecca Garnett, Jon Benner, John Bassett, Bethany Mahre, Robert Chan, Lamare Wimberly, Elijah Porter, Isaiah King, Petra Pearsall
Landscape Architect: PWP Landscape Architecture
Design Team: Adam Greenspan, Peter Walker, Steve Tycz, Conard Lindgren, Seth Rodewald-Bates, Marta Gual, Eustacia Brossart, Julie Canter, Lisa Daye, Matthew Donham, Lauren Hackney, Collin Jones, Pheobe Lickwar, Mi Yang

Consultants
Arborist: Bartlett Tree Experts
Office Interiors: Stantec Architecture
AV/IT Consultant: CallisonRTKL
Café Creative Direction: HFB STUDIO
Civil Engineering: VIKA
Code Review: PFP Engineering and Design
Concrete Consultant: Reginold D. Hough Associates
Cost Estimator: Stuart-Lynn Company
Ecologist: Jeffrey Wolinkski
Elevators: Hector Columbani Associates
Façade Design: R.A. Heintges & Associates
Food Services: JGL Food Service Consultants
General Contractor, Environmental Center: Whitener and Jackson
Geotechnical Engineering: Schnabel Engineering DC
Graphic Design: 2x4
Irrigation: Sweeney & Associates
M/E/P/FP Engineering: Altieri Sebor Wieber
M/E/P/FP Engineering, Patio: KTA Group
Master Mason: Philip Dolphin
Meadow Consultant: Larry Weaner Landscape Associates
Natural Lighting Design: ARUP New York and London Offices
Owner's Representative: MGAC
Security Consultant: Layne Consultants International
Soil Scientist: Pine & Swallow Environmental
Specifications: Construction Specifications
Stream Restoration Construction: Aquatic Resource Restoration Company
Structural Engineering: Skidmore, Owings & Merrill
Sustainability: Buro Happold
Water Court / Constructed Wetland Engineering: Biohabitats
Waterproofing: Henshell and Buccellato

Windows and Doors Frames: Schüco
Lighting: Bega
Home Automation Solutions: Schneider Electric
Glass: Saint-Gobain

Photography by Iwan Baan

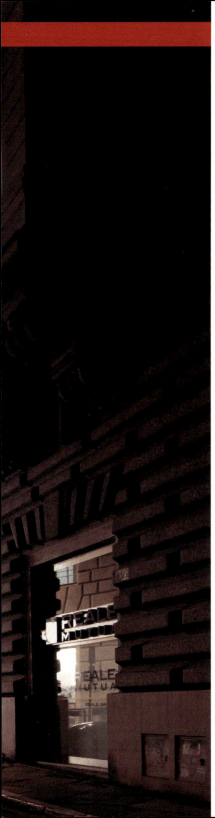

Confcooper Headquarters
Rome, Italy

Confcooper's new headquarters in Rome's historic center is a recovered historic late-19th Century building. Over time, it underwent numerous interventions that modified its layout, distribution and space arrangement. The project by architecture practice It's set out to establish a dialectic relationship between history and contemporaneity, between signs of the past and new additions by leveraging a stylistic approach that gives the building a recognizable identity while acknowledging the different professional environments that operate within it. The building spans six floors to offer a total surface area of some 4,000 sq. m. Every stage of the design process followed a BIM approach, making it possible to combine traditional crafts expertise with new technologies and ensure extreme precision and rapid construction.

Through a process of thickness and material reduction to engender a sense of lightness and spatial cleanliness heightened by the use of lighting, bright colors and the effect of light, inside the building old portions of wall alternate with thin glass, and classic materials such as marble combine with reflective aluminum. Carrara marble prevails for the interior floors, reworked in a contemporary style through reduction into thin slabs with a milky tone, each of which was sized and produced using a BIM model and numerical cutting. The vertical dividing partitions in the work areas are made out of high-performance, minimum-thickness panes of glass, their knurled surface increasing the reflection of external light towards the building's innermost areas while at the same time ensuring privacy for individual offices. A BIM model was also used to calculate and define the optimal ratio between natural and artificial lighting to ensure high levels of visual comfort throughout the workspace.

The staircase connecting the building's different levels all the way up to the roof terrace is an element of flagship design importance. The original staircase was removed and redesigned, with the installation of a white marble and reflective steel ribbon assembled off-site. Architect Alessandro Cambi says: "We emptied the space that contained the staircase and came up with a new reflective steel element, enabling light to travel top to bottom through this large empty space over a 21 m height difference, creating a sort of hollow obelisk that measures the light and the sun's passage".

Externally, the design sought to maximize luminosity by opting for a white treatment of the elevation. This choice radically altered the building's presence within the urban context, setting off a new system of chromatic relations that turn it into a beacon along the through-route between the Church of Santa Susanna and the Basilica of Santa Maria Maggiore.

■ 3D model to study placement
of mechnicals

■ Typical floor plan - Scale 1:300

■ Longitudinal section - Scale 1:400

■ Cross section - Scale 1:400

083

■ View over Via d'Azeglio - Scale 1:400

■ View over Via Torino - Scale 1:400

CREDITS

Location: Rome, Italy
Client: Confcooper Società Cooperativa
Completion: 2018
Gross Floor Area: 4,100 m²
Architect: It's
Main Contractors: Consorzio Consital, CEA Cooperativa
Edile Appennino, L'Operosa impianti

Consultants
BIM: Parallel Digital
Structural: Dedalo Ingegneria
Plant Equipment: AG&C Associati
Safety Coordinator: Francesco Bindi
Landscape: Paisà

Photography by Francesco Mattuzzi
Courtesy of It's

TreeHugger
Brixen, Bolzano, Italy

The winner of an international competition in 2016, "TreeHugger" is a building that houses the Tourist Information Office in Brixen, on a site that from 1800 until the 1970s hosted a series of structures dedicated to tourist reception, each of which was demolished to make way for its successor building.

Located on the edge of the old town, the new pavilion is adjacent to historical architecture (the nearby Palazzo Vescovile) and the Chinese and Japanese pavilions on the corners of the Giardino dei Signori, whose sinuous forms it reinterprets in contemporary guise.

At the heart of the design is a natural element: a monumental *platanus* tree. The building is arranged around the tree, practically embracing it to showcase the union of and interaction between nature and architecture.

TreeHugger spans two levels. On the ground floor, it houses public spaces and information desks, its almost complete glazing an invitation for passers-by to enter, highlighting the concept of transparency and forging relationships with the public and the city. The first floor, where the administrative offices are located, features a more closed, private appearance, with a limited number of openings in its bush-hammered concrete curtain walls.

The plan follows the lot's triangular shape, where two roads converge, albeit softening the forms through the slight convexity of its walls and a circular curvature that envelops the tree. The arrangement of glazed openings on the ground floor and upper level eschews straight lines in favor of soft, sinuous shapes.

The building's design maps out a new square, a public access space partially protected by the upper level's significant overhang; overlooked by five full-height glazed arches, the *platanus* tree area creates an additional open space.

Juxtaposed with the powerful materiality of concrete, through its inviting and welcoming forms, TreeHugger enters into dialogue with the historical context. As well as providing a new focal point for sharing local culture, it offers a new meeting place that attracts a truly mixed audience of visitors and passers-by.

■ Cross section - Scale 1:300

North elevation - Scale 1:300

■ West elevation - Scale 1:300

CREDITS

Location: Brixen, Bolzano, Italy
Client: Associazione Turistica di Bressanone
Completion: 2019
Gross Floor Area: 430 m^2
Architect: MoDusArchitects
Principal Designers: Sandy Attia, Matteo Scagnol
Design Team: Irene Braito, Filippo Pesavento
Main Contractor: Unionbau

Consultants
Structural: Luca Bragagna
Electrical: Elektro Josef Graber
Plumbing: Pezzei

Millwork and Bespoke Furniture: Barth

Photography by Oskar Da Riz
Courtesy of MoDusArchitects

House of Literature
Quebec City, Quebec, Canada

A territory that was a colony of France until the 18th Century and then until 1931 an English colony, Quebec is the largest peninsula and province in French Canada. Its first neo-Gothic church, the Wesley Temple, was built to the design of architect Edward Staveley.

After Canadian independence from the British Empire, the church was converted into a public library and a concert and conference hall for the Institut Canadien de Québec.

The Chevalier Morales-designed Maison de la Littérature is a contemporary extension built on to the old church in order to meet the city's modern needs. Along with restyling the interior and restoring the old ogival windows, the work allowed the Institut Canadien de Québec to continue its cultural mission.

The winner of an architecture competition, this project was chosen because the idea of building a volume outside the church made it possible to preserve the layout of the historic building; indeed, it offered the option of restoring its internal spatiality.

All new amenities such as the concert or lecture hall, the bistrot, the spaces for temporary and permanent exhibitions, the projection room, etc. were moved to the new building, allowing the existing library - one of the oldest public libraries in the province - to maintain its original layout.

On its upper levels, which benefit from an enhanced panoramic view out over the river and city, the architectural extension houses all of the main creative spaces. The House of Literature external façade is made out of glass panels superimposed on perforated brass sheets, animating the surfaces in a dynamic bas-relief. Going for glass was a statement of strong material divergence from the roughness of the raw materials from which the adjacent church was built; at the same time, because they reflect the surrounding environment, this choice succeeds in integrating the new architectural composition into the historic Old Quebec neighborhood, which is a UNESCO World Heritage Site.

The building's partial surface transparency gives the Institut Canadien de Québec an open and contemporary look. Internally, the design deploys a common language throughout the entire architectural complex.

In contrast to the Wesley Temple's light-colored stone façades and the new volume's transparent glass surfaces, the library's interior is dominated by pale, light-hued wooden-slatted parquet and most of the rooms are decorated in smooth white-finish plaster. To break up the predominating light shades, the rooms are furnished with dark-colored armchairs and chairs.

The entire project is characterized by a sober, minimalist design enhanced by the presence of high ceilings set off by an elegant circular chandelier. In harmony with the original ogival windows and ceiling moldings, a white, sculptural spiral staircase dominates the space. Multiple access routes into the structure all converge on the large circular open space on the library floor, vertically connecting the café/bistrot, two exhibition areas and library collections.

Chevalier Morales's design facilitates dialogue between the past and present, in a redevelopment that respects the architectural composition of the existing structure.

■ Axonometric diagram showing
how the new structure fits with
the original building - Not to scale

■ 1st Level plan - Scale 1:400

1- Bistrot
2- Exhibition space
3- Office
4- Training room
5- Storage
6- Dressing room
7- Space for entertainment
8- Residence
9- Multifunctional space
10- Collection
11- Projection room

multilingue

■ Mezzanine floor plan - Scale 1:400

■ 2ⁿᵈ Level plan - Scale 1:400

■ XX Section - Scale 1:400

■ YY Section - Scale 1:400

■ Study model

■ East elevation - Scale 1:400

CREDITS

Location: Quebec City,
Quebec, Canada
Client: Quebec City
Completion: 2015
Gross Floor Area: 1,920 m²
Architect: Chevalier Morales

Consultants
Structural: EMS Ingénierie
Mechanical and
Electrical: Stantec (Dessau)

Ceilings: Armstrong Ceilings

Photography by Chevalier Morales
Courtesy of the author

Southern Utah Museum of Art
Cedar City, Utah, USA

Named after an American philanthropist, the Beverley Taylor Sorenson Center for the Arts hosts visual arts, performing arts, live theater, and art education on the Southern Utah University campus in Cedar City, Utah. The $39.1 million complex is part of a 2,2-ha project that includes the Brooks+Scarpa-designed Southern Utah Museum of Art (SUMA) in its southwest quadrant. Covering an area of some 2,600 sq. m, the building houses exhibitions from around the world, as well as a special collection of works by Utah artist Jim Jones.

The entire local community was consulted during the early stages of the four-year design process, with more than five meta-projects submitted for comments and suggestions. The design team took on this feedback and implemented it in the final structure: transparency and dialogue with the local community avoided misunderstandings and sped up construction time.

The architectural form of the exterior was inspired by white sandstone limestone formations at nearby Bryce Canyon. The roof, which extends an additional 557 sq. m beyond the building's silhouette to provide shelter for outdoor events, features a double curvature reminiscent of American canyon scenery; its wide, monolithic cantilever to the west serves as an important social collector, with a 36.5-m overhang creating a covered outdoor gathering space while protecting the entire glazed façade from direct sunlight. In addition, the inclination of the roof pitch was conceived to drain off and recover rainwater in this harsh local climate.

The building has also adopted unconventional energy efficiency measures to optimize and reduce energy consumption during both construction and in use. Passive design strategies were adopted at the planning stage, including studying the complex' geolocation, analyzing the orientation of its façades, and modelling the volumes according to their exposure to prevailing winds in order to induce natural ventilating currents inside. Large windows maximize natural light, sun shading systems protect the most exposed windows and doors, and light-colored exterior surfaces help make the building 30% more efficient than conventionally-designed similar structures.

Because consumption-awareness is essential for creating optimal conditions for the conservation of artefacts and artworks, and to ensure a comfortable and healthy environment for visitors and staff, the museum is also equipped with a carbon emissions-reducing "trigeneration" system spanning heat, electricity and cooling in a single integrated process. Meticulous analysis of lighting consumption led to the adoption of high-efficiency LEDs, timers and motion sensors to regulate the management of both permanent and temporary light sources.

Sustainability also features widely in the exhibitions SUMA puts on to raise visitors' awareness of our environmental impact and the ecological, economic and cultural consequences of what happens when it is ignored. Temporary exhibitions also employ large quantities of recycled and/or reused materials. The exterior finishes were treated with a natural pigment rather than paint, eschewing the use of any artificial paint products.

The complex also boasts gardens, parks and outdoor spaces for public use planted with local flora that can host meetings and stage exhibitions for up to 300 people.

■ Axonometric diagram - Not to scale
Possible uses of public and outdoor areas

Art show

Dinner

Lecture

■ Axonometric diagram of bioclimatic
features - Not to scale

June 21 Midday

East

December 21 Midday

West

1- Prevailing summer breezes are harvested through porch
2- Porch provides social "handshake" to community
3- West porch overhang prevents direct solar heat gain
4- Rainwater collection from roof is used for landscape irrigation
5- South tree *allée* shades façade

110

■ Ground floor plan - Scale 1:500

■ Cross section - Scale 1:500

■ Longitudinal section - Scale 1:500

KEVIN KEHOE
WESTERN THERAPY

■ South elevation - Scale 1:500

■ East elevation - Scale 1:500

■ West elevation - Scale 1:500

KEVIN KEHOE
WESTERN THERAPY

CREDITS

Location: Cedar City, Utah, USA
Client and Owner: Southern Utah University
Completion: 2017
Gross Floor Area: 2,624.5 m²
Architect and Landscape Design: Brooks+Scarpa
Local Architect: Blalock Partners
Project Team: Lawrence Scarpa, Angela Brooks, Mark Buckland, Chinh Nguyen, Diane Thepkhounphithack, Cesar Delgado, Mario Cipresso, Brooklyn Short, Royce Scortino, Sheida Roghani, Ryan Bostic (Brooks+Scarpa); Kevin Blalock, Rob Beishline, Dugan Frehner, Sean Baron, Charles Gaddis (Blalock Partners)
Project Architect: Emily Hodgdon

Consultants
Landscape: Coen + Coen Partners, G. Brown Design
Structural: Reaveley Associates
Electrical: BNA Consulting Group
Mechanical: Van Boerum & Frank Associates
Lighting: BNA Consulting Group, Luminescence
Civil: Insite Engineering
Acoustics: Fisher Dachs Associates
Specifications: Blalock Partners

HVAC: Mitsubishi
Lighting: Bega

Photography by Tim Hursley (pp. 108, 115, 116), Brooks+Scarpa (p. 117), Ale Scarpa (p. 114), Dino Misetic (p. 113) and Alan Blakely (p. 111)
Courtesy of Brooks+Scarpa

SOUTHERN UTAH MUSEUM of ART
SOUTHERN UTAH UNIVERSITY

Upson Hall
Ithaca, New York, USA

Cornell University Ithaca Campus is a prestigious New York State university founded in 1865. Encompassing some 930 ha, the campus houses laboratories, administrative and academic buildings, sports facilities, auditoriums and museums.

The Sibley School of Mechanical and Aerospace Engineering within the College of Engineering at Cornell University, is located on the Engineering Quadrangle (Quad), at the heart of the University. Here, LTL Architects and Perkins & Will won the commission to renovate Upson Hall, a 15,800 sq. m structure of hybrid engineering labs, classrooms, offices and student project spaces. The new design was conceived to ensure that the building fits in with adjacent structures, while at the same time instilling the engineering quadrilateral with a new identity.

To come up with a truly sustainable, aesthetic transformation of the entire area, which had undergone no modification since not long after WWII, an interdisciplinary team was assembled for the renovation. Working with Thornton Tomasetti and ME Engineers, LTL Architects and Perkins & Will came up with a master plan that featured an energy refurbishment of the previous building that achieves the highest level of energy performance on the entire campus. The approach enabled the team not to distort the physiognomy of the previous building, reproducing the 1956 volumes while transforming a kind of architecture typical of international modernism into a contemporary work that is perfectly inserted into its surrounding context.

The design team retained the existing concrete structure, while transforming the exterior envelop and reorganizing the entire interior program, including research laboratories, classrooms, offices, and student project labs. To foster interdisciplinarity and dialogue among the various departments, ample public spaces were created within the structure through social and visual connections. Located at key connecting hubs to enliven student and staff life, many of these areas cantilever out from the previous structure.

Following an integrated approach to façade design and energy planning, the design's wideranging system rolled out specific responses to local climatic characteristics. A metaphorical "transparent blanket" envelops the entire building, alternating large glazed openings to maximize daylight, especially in collective meeting places in the building's corners, with highly-insulated walls that shield the structure from harsh winter cold.

The design transformed the previous modernist façade, characterized by long strips of ribbon windows that made it impossible to properly divide the interior spaces, into a façade that may be adapted to meet new requirements for flexible, energy-efficient laboratories.

The division of internal space placed the school's administrative center in an area by the main entrance, adjacent to a new staircase that connects the five floors of the university complex. The ground floor is occupied by student project rooms and workshops, including the Emerson Manufacturing Lab, the Experimental Learning Lab, and the GM Automotive Lab. The first floor is characterized by a special 76-m-long ceiling and a display case that showcases the famous Reuleaux Collection of Mechanical Movement Systems. The second floor is dedicated to teaching: classrooms and laboratories, wind tunnels, rooms equipped for dynamic material and fluids testing, and laboratories for heat experiments. The three upper floors are given over to research laboratories, offices and support spaces.

■ Axonometric diagram

1- Before
2- On project completion

1

2

■ East elevation - Scale 1:500

CREDITS

Location: Ithaca, New York, USA
Client: Cornell University
Completion: 2017
Gross Floor Area: 15,865 m²
Cost of Construction: 43,484,560 Euros
Architects: LTL Architects and Perkins & Will
General Contractor: The Pike Company

Consultants
Structural and Façade: Thornton Tomasetti
MEP/FP: ME Engineers
Lighting: Lumen Architecture
Landscape: Trowbridge Wolf Michaels
Civil: TG Miller PC
**Technological, Audio-visual Equipment
and Acoustics:** The Sextant Group
Code Compliance: Code Consultants
Professional Engineers, PC
Cost Estimator: Faithful + Gould

Acoustic Ceilings: Armstrong Ceilings

Photography by Michael Moran/OTTO
Courtesy of the author

Atelier Alice Trepp
Origlio, Switzerland

To integrate architecture and nature presupposes paying close attention to environmental protection. This is something that, due to the incessant anthropization of the Earth, is now a priority for contemporary designers. Mino Caggiula Architects, a Swiss firm based in Lugano, has always been committed to protecting the environment and preserving local territory from uncontrolled urban "sprawl". With its uncontaminated mountain landscapes, Canton Ticino offers a fine opportunity to showcase how architecture can, without losing its identity, blend in with nature.

Inspired by the natural landscape, Mino Caggiula Architects have redrawn the forms of contemporary architecture for artist Alice Trepp in a country home surrounded by greenery, the sinuosity of its forms visible in an alternation of solid raw, reinforced concrete with the lightness of large, unbroken windows.

Cleverly integrated into its surrounding nature, Atelier Alice Trepp stands out from the local vernacular architecture without impacting the local milieu. Achieving this kind of synergy between nature and architecture is posited on establishing a trust-based, balanced relationship between the client's wishes and the architect's creative skills.

When commissioning her new home-*cum*-atelier, sculptress and artist Alice Trepp said she imagined living in Switzerland in a typical Tuscan-style villa, with a couple of outhouses, open spaces and a pitched, tiled roof. The architects took the artist's desires on board and then turned the initial idea on its head by suggesting a modern, functional counter-proposal: a form of architecture that puts nature and place at the very heart of the proposal. Not only was the artist intrigued by the new proposal: she fell in love with it on the spot. The project is located in a place of rare tranquility: the village of Origlio, its particular beauty enhanced by a small lake with a promenade around it.

The underlying inspiration for Mino Caggiula Architects' design concept was to extrude the contour lines on the building lot. No obvious interruptions mar the natural landscape or the building, whose sinuous shape lightens the sculptural structure of exposed reinforced concrete; by terracing the floors, it was possible to create green roofs where plants cover a large swathe of the underlying frontage.

This man-made shelter incorporates natural features in what is an example of contemporary architecture plugged right in to the landscape, using raw materials shaped and formed to follow the contours sinuously. Ample glazing picks out the form silhouette, allowing views far and wide over the entire valley while at the same time considerably reducing the material footprint on the local environment, characterized by a sense of space inspiring ancient evocations.

The entire design at Atelier Alice Trepp revolves around the concept of a cenote, a depression in the earth surrounded by greenery, with light cascading down into the water below. This feature, here manifested as a burnished hole in the ceiling, is covered with hanging jasmine as it overlooks a 30 cm-high infinity pool. The architectural cenote acts as a veritable natural clock, altering the colors in the indoor spaces as the sun moves along its path.

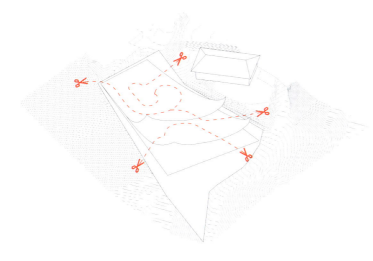

■ Axonometric diagram showing site interventions required

■ Axonometric diagram of solar exposure

■ 1st Floor plan

1- Cenote
2- Plaster room
3- Spa
4- Utility room
5- Artist's studio
6- Kitchen
7- Living room
8- Bedroom
9- Closet
10- Biopool

m 0 1 2 3 4 5 6

1- Cenote
2- Plaster room
3- Spa
4- Utility room
5- Main entrance
6- Vehicle access ramp

m 0 1 2 3 4 5 6

CREDITS

Location: Origlio, Switzerland
Client: Alice Trepp
Completion: 2019
Building Area: 454 m²
Cost of Construction: 5,634,864 Euros
Architect: Mino Caggiula
Project Architect: Alberto Bernasconi
Executive Architect: Andrea Maldarizzi
Design Team: Laura Martinez, Maurizio Civelli

Consultants
Electrical: Evolve
Structural: Pianifica
Landscape: Living Natura Landscape
Kitchen Equipment: MV Design
Building Physics: Evolve
Fire System: TEA Engineering

Photography by Paolo Volontè
Courtesy of Mino Caggiula Architects

Town Hall Hotel
London, UK

Bethnal Green Town Hall on Cambridge Heath Road was originally built in 1910 by architects Percy Robinson and William Alban Jones in a reinterpretation of Baroque style. In 1937, the building expanded onto Patriot Square to reach a total area of 7,500 sq. m. The local council used the building as its base until 1993, when the building was vacated and fell into disuse.

Despite its obsolescence, the interiors were frequently used as locations for films and TV series until 2007, when Singaporean hotelier Peng Loh purchased the entire property.

Before the purchase, Michel da Costa Gonçalves, DROO, and Nathalie Rozencwajg, NAME, came on board as consultants under RARE Architecture; after the acquisition, they were commissioned as architects to breathe new life into this historic specimen of architecture.

Without distorting its existing physiognomy, restoring it where necessary and increasing usable space by adding a volumetric extension, the investment has converted the structure into a contemporary luxury hotel. While maintaining respect for its history, the restoration and rehabilitation project gave the Bethnal Green Town Hall a new lease of life.

Before redeveloping the existing structure, the architects meticulously researched the archives to learn about the building's original architectural design elements. Skilled craftsmen were hired to restore the former patinas on the marble floors, decorated ceilings and Art Deco details. DROO and NAME used state-of-the-art design technology approved by the UK Department of Heritage Protection to achieve their goal. The same techniques are evident both in the longitudinal extension and the additional floor added above the former flat roof: these new volumes are entirely encased in a powder-coated, laser-cut aluminum skin to create an abstract backdrop that throws the original structure into even greater relief.

The tightly-packed metallic grille pattern obscures all of the building's windows and openings from outside view, making a clear statement of detachment and personality in this juxtaposition of old and new. The envelope's parametric motif recurs as a hallmark feature of the new interior design, appearing on air conditioning vents and wall decoration panels.

Because the hotel's 98 rooms are of different sizes, the designers came up with a unique and personalized layout for each one of them. The interior redesign allowed DROO and NAME to standardize interior design choices and furnishing style, creating ample spaces of contemporary comfort while maintaining a clear distinction between new and restored elements. Bespoke beds, desks, kitchens and bathroom suites were commissioned to be made from precious and refined materials: MDF fiber panels were milled on numerical control machines, along with Corian, Green Lime marble, oak, and Cardoso and Vals stone.

The restyle went beyond the hotel rooms too: the structure was equipped with a new 14 m titanium-tiled swimming pool in the basement, a conference room carved out of the previous council chamber, and a bar/restaurant in the original part of the building, where the exclusive Viajante restaurant boasts custom-made furniture designed by DROO, decorated with tapestries and silicone chandeliers designed in partnership with Tzuri Guetta.

■ Axonometric diagram showing how the new
envelope overlaps the heritage building

■ Study diagram of the envelope apertures

CURVE PATHS & HEIGHTS ESTABLISHED

PATHWAYS & INTERSECTIONS DEFINED

VIEWS & LIGHT PENETRATION HEIRARCHIES ESTABLISHED

ACTUAL PERFORATIONS WITHIN METAL SCREEN

■ 1ˢᵗ Floor plan - Scale 1:600

■ Roof plan - Scale 1:600

CREDITS

Location: London, UK
Client: Mastelle (Zinc House)
Completion: 2011
Gross Floor Area: 9,000 m²
Architects: DROO - Da Costa Mahindroo Architects
(designed by Michel Da Costa Gonçalves and
Nathalie Rozencwajg under RARE Architecture)
Project Architects: Michel da Costa Gonçalves (DROO),
Nathalie Rozencwajg (NAME)
Design Team: Carl Greaves, Coralie Huon, Agata Borecka,
Julien Mirada, Luca de Gaetano, Anne Paillard, Julien Loiseau,
Claude Ballini, Taeho Kim, Duncan Geddes, Calvin Chua, Kai Ong
Main Contractor: MP Brothers

Consultants
Structural: O'Connor Sokolowski Partnership
M&E: Mendick Waring
Quantity Surveyor: Barrie Tankel Partnership
Heritage: Priory Heritage
Planning Supervision: Prospect planning
Lighting: Jonathan Cole Lighting

Windows: Schüco
Sanitary Ware: Duravit

Photography by Ed Reeve (pp. 143, 144) and
Sue Barr (pp. 138, 141, 142, 146, 147)
Courtesy of DROO - Da Costa Mahindroo Architects + NAME

Kálida Sant Pau Centre
Barcelona, Spain

Barcelona's Kálida Sant Pau Centre, the first Maggie's Centre building in continental Europe, occupies the site between the new Sant Pau hospital and the old hospital complex designed at the beginning of the 20th Century by the Modernist architect, Lluís Domènech i Montaner.

Well known in the United Kingdom, the Maggie's Centre network provides facilities near hospitals where cancer patients and their loved ones can find comfort and support in beautiful surroundings with an abundance of greenery that help alleviate the pain and distress often accompanying disease. The project by Miralles Tagliabue EMBT has now brought this experience to Barcelona with a 400 sq. m two-story building containing spaces for medical assistance but also for conviviality, including a small library.

Dialoguing with the nearby architecture of Domènech i Montaner, the Kálida Centre plays with a flower-shaped plan, a material mix of brick, terracotta and wood, and the use of color in both the garden and interiors. Patricia Urquiola authored the interior design: her furniture, its colors and the materials used for the accessories create a series of extremely comfortable interior spaces, welcoming, home-like environments conducive to making patients feel at ease.

Benedetta Tagliabue took us over the history and significance of this project.

The Kálida Centre is the first Maggie's Centre building in continental Europe. What personal and professional significance does this project hold for you?

My relationship with this project is a very personal one. It takes me back to the time when my husband, Enrique Miralles, and I were confronted with his illness. We went to Houston for treatment, and there, in this huge anonymous hospital, we found a place designed especially to help alleviate the distress and pain of those who were going through the same experience we were. All sorts of courses were on offer, and we found what interested us most and matched what we were feeling. I received an enormous amount of help there, which is why about 12 years later I enthusiastically accepted the proposal of a group of women to give Barcelona a Maggie's Centre facility, a network they themselves had benefited from in the United Kingdom during their own treatment.

We had nothing at the beginning excepted our strong resolve, spearheaded in particular by one of these women, Rosie Williams. It was this determination that finally got the project realized.

Can you tell us how the project got underway and was completed, and also how it relates to the nearby Modernist architecture of Domènech i Montaner?

At the outset there were many contacts with Maggie's. Subsequently, however, they decided against being directly involved with the building of the center because funding outside the United Kingdom would have been too complicated. So the Catalan Kálida Foundation stepped in and became associated with Maggie's, allowing our idea to become a reality.

The decision was taken to place the building in the grounds of the Sant Pau Hospital. It is interesting how Domènech i Montaner's overall idea for the Sant Pau in fact reflects exactly what Maggie's Centres are all about. The Sant Pau was designed with the poor in mind, not just as a functional

facility but as a place full of beauty. It was the conviction of the hospital's financier that beauty would alleviate the pain of disease, and would make it easier for people to actually go to the hospital. In fact, the hospital is articulated as a series of pavilions set in a garden, which led the architect to make wide use of materials like ceramic and brick, typical features of Barcelona itself. So the Sant Pau is far from the classical image of a hospital.

What role does architecture play in helping people during difficult times in their lives?
When I started getting involved in this project, the question of designing architecture that would induce wellbeing became a central issue for me, and now we apply this to all the work done by our practice, whatever the scale, whether urban or domestic.
The topic of the home as a place for wellbeing has also become a highly topical theme. Finding ourselves all of a sudden locked up, "prisoners" in our own homes, has made us much more aware of the importance of comfort, and the need for well aired, well-lit spaces made of materials that are pleasant to the touch. It has also made us reassess the whole question of public spaces that we found ourselves longing for.

How can things like materiality, space and color create environments that give us pause and moments of calm? What role does a touch of irony and playfulness have in architecture?
For me, choosing materials comes down to gut feeling. But behind every material there is a story, a link with craft traditions and with the architecture of the place in which we are working. For example, ceramic is a key element of the Catalan tradition, and especially its Modernist architecture. With ceramic you can introduce all manner of colors that do not fade over time.
It was very interesting to play with this, and with the inferences from the architecture nearby, trying to set up a sort of dialogue. Although practically the same type of ceramic as that produced a hundred years ago is still available today, we chose to use a more elementary, economical product as our building was financed by donations and so could not be costly. It was important not to spend very much and so we used readily available ceramics playing with different shades and painting only a few with white lacquer.
Domènech i Montaner really strived to imitate flowers; the flower theme expresses all the nostalgia for the natural world that characterizes Art Nouveau, or Liberty, Déco, and also Modernism, which included nature in architecture.
We imitated the floral motifs especially in the building's geometry, but when we developed the geometry of the façade we referenced the sky and the clouds. Then, playing with these Modernist themes, we reintroduced a simplified form of the Catalan vault, a typical building feature of Barcelona, renewing the tradition and rendering it more playful.
And then we used timber, a material we love; warm and sustainable, it lives and becomes renewed.

All projects are also about interpersonal relations, especially with the client but also obviously with colleagues and co-workers. On this occasion you collaborated with Patricia Urquiola, who produced the interior design. What can you tell us about this experience?
I get on very well with Patricia. We have known each other for a very long time and recently we have met often for professional reasons. She told me that she felt the need to give back, and so I proposed she be part of this project. Patricia was exceptional. She accepted to design the interior when the building was already decided on, already done, and she came into it respecting my work.

151

Then, she succeeded in convincing her manufacturers to donate a series of wonderful furniture, designed by her and beautifully made. It is a fantastic plus for the Kálida Centre.

In your professional experience you have tackled projects of all sizes, from design objects and installations to large-scale urban and infrastructure programs. How does your approach change with the size of the project? Do you have a particular scale you prefer to tackle and with which you feel most in tune?

Small, immediate things like installations have always been where I find relaxation and can experiment.

It is also very important for a practice to do large scale things because it is on this scale that you come up against the small decisions. In fact, our practice is now doing more large-scale buildings, and now that we are working with Asia and China we are proposing large scale buildings, urban projects and public spaces.

I like working at any scale but the small scale, I think, helps maintain an awareness of what one is doing.

It is important to retain an ability to work at all scales, which is a typical capacity of our architects, who play the role of directors in any project.

■ Rendering and study models

■ Ground floor plan - Scale 1:200

1- Entrance
2- Kitchen
3- Dining room
4- Reading corner
5- Multifunctional room
6- Seating area
7- Counseling room
8- Offices and meeting room
9- Terrace

■ 1ˢᵗ Floor plan - Scale 1:200

■ Roof plan - Scale 1:500

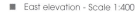
East elevation - Scale 1:400

South elevation - Scale 1:400

CREDITS

Location: Barcelona, Spain
Completion: 2019
Gross Floor Area: 400 m²
Costs: 1,850,000 Euros
Architect: Miralles Tagliabue EMBT
Design Principals: Benedetta Tagliabue, Joan Callís
Project Coordinator: Valentina Nicol Noris
Design Team: Enrico Narcisi, Gabriele Rotelli,
Marianna Mincarelli, Paola Amato, Helena Carì,
Astrid Steegmans, Lisa Zanin, Federico Volpi, Letizia Artioli,
Giovanni Vergantini, Paula Gheorgue, Esther Saliente Soler,
Vincenzo Cicero, Sofia Barberena, Philip Lemanski,
Marco Nucifora, María Cano Gómez, Carlo Consalvo,
Luis Angello Coarite Asencio, Teymour Benet,
Cecilia Simonetta, Edurne Oyanguren, Yilin Mao,
Marilena Petropoulou, Ludovica Rolando, Mikaela Patrick,
Erez Levinberg, Pablo López Prol, Mabel Aguerre
Interior Design: Patricia Urquiola Studio
Main Contractor: Construcciones Pérez Villora

Consultants
Structural: Bernúz Fernández Arquitectes
Electrical and Mechanical: PYF
Quantity Surveyor: Borrell Jover SLP

Timber Advice: American Hardwood Export Council (AHEC)
Floor Coverings: Listone Giordano

Photography by Duccio Malagamba
Courtesy of Miralles Tagliabue EMBT

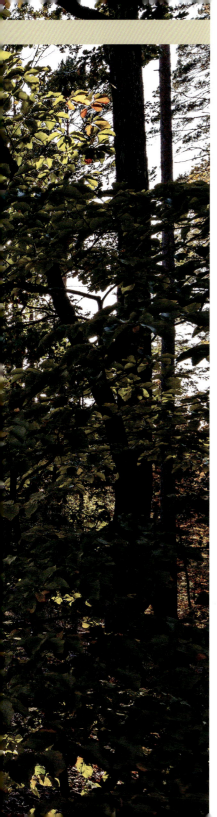

Chapel Ruhewald at Tambach Castle
Weitramsdorf, Germany

One of Germany's 16 *Länder* (or regions), Bavaria, is also one of the country's largest most populous regions. Its famous cities and spectacular mountain landscapes also make it a popular tourist destination. Its renowned mediaeval castles are a major attraction, Neuschwanstein Castle being the most famous and taken by Walt Disney as the backdrop to some of his most famous animated films.

The 17th-Century baroque castle of Tambach in Weitramsdorf in northern Bavaria, on the border with Thuringia, is now owned by Heinrich Graf zu Ortenburg. Its position in the midst of a forest far from frenetic city life led the owner to create the Ruhewald Schloss Tambach, a retreat amidst nature where visitors can enjoy peace and serenity in a completely natural setting, and the center of a pantheist cemetery offering a final resting place in the forest.

The Weitramsdorf Woodland Cemetery has a strong resemblance to Stockholm's Woodland Cemetery, declared a UNESCO World Heritage Site some 20 years ago, and considered one of the world's major examples of Modernist architecture embodying the secular Nordic concept of life. In all religions and cultures, the cemetery and burial of the dead are important, meaningful concepts demanding appropriate structures and dedicated areas. This was the motivation behind the Ruhewald Schloss Tambach Chapel, a secular sanctuary and place of worship dedicated to the contemplation of nature and meditation.

Designed by the Parisian firm sacher.locicero.architects, the chapel was built to the physical proportions of the Golden Ratio - used by Leonardo da Vinci for his Vitruvian Man - and seems to embody Baruch Spinoza's *Deus sive Natura* philosophy. Indeed, the aim of creating a man-made structure completely at one with nature is to instill a sense of simplicity and harmony, allowing visitors to commune with the forest and their loved ones.

The 35 sq. m chapel is appropriately built entirely of local timber. The seven light-colored timber ogees making up the frame span the entire internal surface area. The first arch at the entrance is 4.79 m high - exactly the width of the chapel. The subsequent arches rise progressively to the 7.75 m of the last arch, which is exactly the length of the chapel. The outer cladding of larch shingles serves as a roof while the entrance elevation and its opposite end are completely glazed to allow natural daylighting and create a continuum between inside and out.

The environment is furnished sparingly with just three wooden benches and three altar elements. Just outside the entrance, a small parvis serving as an outdoor devotional space is an area of transition from the chapel into the forest, as aptly indicated by the uneven pattern of the porphyry paving. To the side of this external devotional area, hued rocks of Bamberg sandstone provide seating for visitors, who even when the chapel is closed can rest and be enveloped in the special atmosphere exuded by this place where architecture, nature and man come together.

■ North elevation - Scale 1:100

■ South elevation - Scale 1:100

175

■ Ground floor plan - Scale 1:100

■ Longitudinal section - Scale 1:100

CREDITS

Location: Weitramsdorf, Germany
Client: Heinrich Graf zu Ortenburg
Completion: 2018
Gross Floor Area: 36 m²
Architect: sacher.locicero.architects

Glass: Saint-Gobain

Photography by Sebastian Kolm
Courtesy of sacher.locicero.architects

Lebanese American University Library
Byblos, Lebanon

The UNESCO World Heritage Site Byblos in Lebanon is home to the oldest archaeological finds of the Phoenician era. Phoenician culture was the first to codify an alphabet with almost all of the sounds we use in today's languages.

The city's language associations are evident in the name Byblos, which recalls the Greek word *biblíon* (meaning "book"); the same root is used in many Romantic languages to denote the word for "library".

Against this cultural and historical backdrop, the Lebanese American University (LAU) commissioned the Byblos University Library and Central Administration project, consisting of new library and administrative buildings from Atelier Pagnamenta Torriani (A•PT Architecture), an international architecture firm founded in 1992. The New York-based practice commissioned to design the two new buildings specializes in designing cultural and academic buildings that redraw the boundaries between public and private.

As per the LAU plan to compete with leading American universities around the world, the project is part of a broader strategic scheme to leverage the latest cutting-edge technological systems in a new architectural complex, improving communication between the campus and the library, and recasting relationships between students, faculty and visitors.

The complex and dynamic shapes of the buildings' fronts operate as a form of architectural transference for the region's stratification and historical complexity. Optimizing orientation and shading with respect to solar inclination, the external surface skin is made from different layers of material, in an overall design approach that maximizes internal daylight to facilitate reading and reduce consumption of artificial light.

The designers achieved visual continuity between the exterior and interior through open, dynamic and flexible rooms and environments. No obvious breaks interrupt continuity between the outdoor public spaces around the buildings and their indoor study/work areas. Every element was designed to facilitate connections and user interaction. This is evident in the lounge area, café area and the open staircase.

The buildings' glazed and transparent fronts are interspersed with a concrete wall above the amphitheater, on which the letters representing the four alphabets historically used throughout the region are carved out within regular frames: Phoenician, Greek, Latin and Arabic. Repeated on the sunshade panels, this pattern unifies and enlivens both buildings' fronts.

Energy sustainability was key in designing the complex interior. The structure's passive systems were inspired by local building typologies. A double outer skin allows for ventilation and shading to all fronts, while the library's large open atrium provides an outlet for continuous air recirculation.

Eco-friendly solutions include employing renewable and recycled materials, a waste water reuse and conservation system, solar energy, and planting native plant species in the surrounding landscape.

The Byblos University Library and Central Administration is a beacon for a 21st-Century library conceived for academic activities and social life combined within the same building, fostering dialogue, communication, learning and understanding among different people and cultures.

■ Northeast elevation - Scale 1:500

■ Southwest elevation - Scale 1:500

■ Study diagram of the volumes, defining the main forms and functions

■ Site plan - Scale 1:700

■ Exploded axonometric view of the vegetation and the functions on each level

Office Staff

Modular studing Space

Study Rooms

Books Area

Flexible Space

Offices

Offices

Workstations

Lobby

Gallery

Lobby

Offices

Workstations

Net Cafe

Stage

Multipurpose Rooms

Amphitheatre

Gallery

Books Area

Technical Rooms

■ Exploded axonometric view showing the different types of envelope

N

■ Cross sectional view of bioclimatic features
 Not to scale

1- Daylight penetration
2- Double skin façade and heat dissipation
3- Skylight atrium with chimney effect
4- Operable windows
5- Natural sunshading corridor

CREDITS

Location: Byblos, Lebanon
Client: LAU - Lebanese American University
Completion: 2019
Building Complex Area: 8,200 m²
Design Architect: A•PT Architecture
Atelier Pagnamenta Torriani
Engineer / Architect of Record: Rafik El Khoury and Partners
Project Management: DJ Jones & Partners
Main Contractor: NATCON Engineering and Contracting

Photography by Jad Sakr (pp. 172, 175, 178, 179, 180, 181)
and Hans Demarmels (p. 176)
Courtesy of A•PT Architecture - Atelier Pagnamenta Torriani

DIETRICH | UNTERTRIFALLER ARCHITEKTEN

Courtesy of Dietrich | Untertrifaller Architekten

Dietrich | Untertrifaller Architekten, founded in 1994 in Bregenz, are typical representatives of the famous Vorarlberg school. The office is headed by Helmut Dietrich, Much Untertrifaller, Dominik Philipp and Patrick Stremler, and today employs an international team of 110 architects based in Austria (Bregenz and Vienna), Switzerland (St. Gallen), France (Paris) and Germany (Munich). Dietrich | Untertrifaller have realized numerous projects in France, Germany and Switzerland in recent years and are set to further expand their international presence in the future.

Always carefully and at the same time confidently, the office creates architecture from its respective context - restrained in style with spatial sophistication and demonstrating a finely nuanced materiality. The entire spectrum ranging from large-scale buildings and urban structures through alterations of existing buildings to single-family homes defies specialization, constantly challenges and inspires creativity and an inquiring mind.

Flashy architecture in the formal sense is not their style, but rather exciting architecture is, which they always develop from the relationship to the respective place and its environment and the required program. A decisive factor in all their work is the resource-saving and appropriate use of materials and structures, with a particular interest in and commitment to contemporary timber construction.

OOPEAA

© Pekka Turunen, courtesy of OOPEAA

Anssi Lassila is the founder and director of OOPEAA Office for Peripheral Architecture and Professor of contemporary architecture at the Oulu School of Architecture. His architecture combines a sculptural form with traditional materials and innovative techniques. Placing the human being at the center, he has a keen interest in exploring the potential of wood as a sustainable solution and in developing new systems of modularity.

His personal experience in working with wood extends from building with hand carved logs to the use of CLT. OOPEAA works on a wide range of projects from churches and public buildings to housing and urban visions. There is an active focus on research and development with an emphasis on solutions that support social and ecological sustainability. The office is based in Seinäjoki and Helsinki, Finland, and it currently employs a staff of twenty.

For OOPEAA the notion of the peripheral is an important starting point. It emphasizes the fact that what one sees as the center or as the periphery is always relative to one's own position, and that there is always a distance between the two. It implies a sense of looking at things from an outside position while embracing the knowledge and understanding offered by an insider.

The work of OOPEAA and Anssi Lassila has been recognized with some of the highest merits achievable. Their work has been selected for the shortlist for the Mies van der Rohe Award in 2005, 2011 and 2017, and nominated for the 2019 edition of the prize.

© Mads Mogensen, courtesy of
noa* network of architecture

NOA* NETWORK OF ARCHITECTURE

The studio was founded in 2011 by Lukas Rungger and Stefan Rier in Bolzano, Italy, and in 2018 a second office was inaugurated in Berlin. Noa* is a network of young architects and designers, which explores an interdisciplinary approach to each project and a holistic strategy for constructive and material choices.

The dialogue with the landscape is an important aspect for all of the practice's work, which interprets the alpine tradition according to a contemporary language aimed at a continuous aesthetic and formal research.

Stefan Rier was born in Bolzano in 1979, he graduated in Interior Design at the Andrea Palladio Study Center in Verona and in Architecture at the University of Ferrara. Lukas Rungger was born in Bolzano in 1977, he graduated from the Technical University of Graz (TU Graz). Both of them, after a decade of experience at national and international studies, returned to Milan, where they met at the atelier Matteo Thun & Partners. In 2011 they founded the noa* network of architecture studio in Bolzano, which deals with design and projects in the hotel, residential, catering, contract and landscape design sectors.

Courtesy of RDHA

RDHA

RDH Architects (RDHA) is a Toronto-based studio specializing in architecture for the public realm. Founded in 1919, it is one of Canada's oldest architectural practices and is the recipient of the 2018 Royal Architectural Institute of Canada (RAIC) Architectural Firm Award. Led by principals Bob Goyeche, Geoff Miller, and Tyler Sharp, the firm of 25 professionals has developed an extensive portfolio of experience encompassing industrial, offices, libraries, recreation, post-secondary education, transit and secure facility design.

Over the past 12 years, the firm has focused on producing intelligent, concept driven architecture of the highest caliber. RDHA now feel and act like an emerging design studio, while their 100-year legacy provides a solid backbone of technical and managerial experience. Consequently, RDHA have re-emerged as one of Canada's acclaimed design firms, with over 60 provincial, national and international awards - most notably three Governor General's Medals, the 2014 Royal Architectural Institute of Canada Young Architect Award for design partner Tyler Sharp.

Courtesy of Ennead Architects

ENNEAD ARCHITECTS

Ennead Architects is an internationally-acclaimed, New York-based studio with offices in New York City and Shanghai. Renowned for its educational, cultural, scientific and governmental building designs that authentically express the progressive missions of their institutions and enhance the vitality of the public realm, Ennead have been a leader in the design world for decades.

Recipient of the prestigious AIA NY Medal of Honor, the Smithsonian Institution-Cooper Hewitt National Design Award and the National AIA Firm Award, as well as numerous design awards for individual buildings, the studio has a portfolio that is diverse in typology, scale and location and includes new construction, renovation and expansion, historic preservation, interior design and master planning.

Ennead's collaborative process is rooted in extensive research involving the analysis of context, program, public image, emerging technologies and a commitment to sustainable solutions. Eleven partners lead the firm: Timothy Hartung, Duncan Hazard, Guy Maxwell, Kevin McClurkan, Molly McGowan, Richard Olcott, Susan Rodriguez, Tomas Rossant, Todd Schliemann, Don Weinreich and Thomas Wong.

© Bill Timmerman, courtesy of
Wendell Burnette Architects

WENDELL BURNETTE ARCHITECTS

Wendell Burnette Architects is an internationally recognized architectural practice based in Phoenix, Arizona (USA). Their portfolio of work includes a wide range of private and public projects. The specific focus of the practice is concerned with space and light, context and place, and with the environment and landscapes in which we live. The architecture of the firm responds to the specifics of site and client needs, is resourceful in regards to budget, takes a pro-active approach to the craft of building, and strives to create spaces that engage people. Wendell Burnette Architects' work is always derived from a careful reading and understanding of place and client.

Each project is unique, and they creatively endeavor to discover an architecture that has a deep resonance with the history and culture of its site.

Wendell Burnette is a self-taught architect whose design philosophy is grounded in listening and distilling the essence of a project to create highly specific architecture that is at once functional and poetic. He is born in Nashville and discovered the southwest desert as an apprentice at Frank Lloyd Wright's Taliesin West. He was Professor of Practice at The Design School at Arizona State University from 2000 - 2015 and still teaches visiting studios and lectures widely in the United States and abroad.

Wendell Burnette Architects' projects include residences located locally and nationally, as well as current work in China, Canada, Israel, Saudi Arabia and the UAE. The work of the firm has been published in more than 200 publications worldwide and has earned numerous distinctions for Design Excellence. The firms' first full-length monograph *Dialogues in Space* was released worldwide in 2015.

© Scott Frances, courtesy of
Thomas Phifer and Partners

THOMAS PHIFER AND PARTNERS

Since founding Thomas Phifer and Partners in 1997, Thomas Phifer has completed expansions of the Glenstone Museum in Potomac, Maryland, the Corning Museum of Glass in Corning, New York, and the North Carolina Museum of Art in Raleigh, North Carolina, as well as numerous domestic, public, educational, commercial and governmental projects. Thomas Phifer and Partners has received three Design Excellence awards from the General Services Administration and more than 20 honor awards from the American Institute of Architects. The firm's projects have been published and exhibited extensively in the United States and overseas.

Mr. Phifer received the prestigious Rome Prize from the American Academy in Rome in 1996 and was awarded the Medal of Honor from the New York Chapter of the American Institute of Architects in 2004. He was elected as an Academician of the National Academy of Design in 2011. In 2013, he received the Arts and Letters Award in Architecture from the American Academy of Arts and Letters. In 2016, he was honored by the New York Chapter of the American Institute of Architects with the President's Award and by the Sir John Soane's Museum Foundation, and gave the keynote lecture at the Royal Institute of British Architects in London. In 2019, he was awarded the National Design Award in Architectural Design from the Cooper Hewitt Smithsonian Design Museum. He is a Fellow of the American Institute of Architects and serves on the boards of the Architectural League of New York and the Sir John Soane's Museum Foundation. Thomas Phifer has served as a visiting professor at numerous schools, including the Yale School of Architecture, the Columbia Graduate School of Architecture, Planning and Preservation, the Cooper Union, the University of Southern California, the University of Texas, and the Cornell University College of Architecture, Art, and Planning.

Courtesy of It's

IT'S

It's is a company aimed at research and innovation, founded in 2016 by Alessandro Cambi, Francesco Marinelli and Paolo Mezzalama with branches in Rome, Geneva and Paris. It's addresses itself to public and private sector firms who look for both ethical and economic potential in innovation, within which the architect's point of view can bring added value.

Today, the group has already developed projects for Amazon, the Lombardy Region, Grisoni Zaugg, Bouygues Immobilier, SNCF, UCI Cinema, Feudi di San Gregorio, Bang&Olufsen.

Alongside It's appears Parallel Digital, a startup in the avant-garde of the development of design using the BIM method and digital experimentation.

© Marco Pietracupa, Valentina Cameranesi, courtesy of MoDusArchitects

MODUSARCHITECTS

MoDusArchitects was founded by Sandy Attia and Matteo Scagnol in 2000. The studio distinguishes itself within the international architectural panorama by the bold and heterogeneous body of work that intertwines the founding partners' two different formative and cultural backgrounds.

Since its inception, MoDusArchitects addresses multiple topics, scales and programs and pursues a design process that holds steadfast the relationship between ideas and buildings. The projects are careful studies of the places and contexts in within which they are situated to produce surprising architectural vocabularies that combine an approach that is both intuitive and grounded in the tectonics of the architectural discipline.

MoDusArchitects' work has been recognized with a number of important publications and awards, including a nomination for the Mies van der Rohe Award in 2015. The Kostner House and Studio project together with the Damiani Holz&Ko Office Building project are part of the MAXXI Museum's permanent collection in Rome. Matteo Scagnol and Sandy Attia flank their professional work with their academic roles at Princeton University's School of Architecture, USA.

Courtesy of Chevalier Morales

CHEVALIER MORALES

Stephan Chevalier and Sergio Morales founded Chevalier Morales in 2005. The firm strives to create contemporary architecture that is sensible and responsible on many levels. Understanding the intrinsic qualities of materials, shades of lights, shapes and spaces that will affect the users' experience, they are equally conscious of people's needs, ideas and comfort as they may become users of Chevalier Morales buildings. Their work is not only environmentally responsible but also community-oriented. Today's environmental problems and challenges like energy waste, pollution, global warming and insufficiency of drinking water are all addressed in Chevalier Morales' interventions, not only aesthetically or as a trend, but truly as an architect's fundamental responsibility.

In this information era of abstract speeds, instantaneousness and globalisation, architectural trends are numerous and diversified. Western 20th Century values like multiplicity, exactitude, lightness, speed and precision, reminders for a new millennium (Italo Calvino, *Six Memos for the Next Millenium*, 1989), are part of the Chevalier Morales vision where movement, territory and identity hold an important place. This set of values allows the architect to consider the building as an intervention that exceeds its own limitations and can influence territory, identity and community. Their inspiration stems in a broader reading of context, and therefore results in architecture that is a critical review of its own surroundings. Generalists in a construction industry where specialization is common, the partners believe that their role as architects is very similar to one of a conductor; coordinating, leading and gathering people together around a common social project while making sure that, in the end, the product will be as rigorous, as coherent and as esthetically pleasing as was envisioned during the first stages of design.

BROOKS+SCARPA

Courtesy of Brooks+Scarpa

Brooks+Scarpa is a collective of architects, designers and creative thinkers dedicated to enhancing the human experience founded in 1991 as Pugh + Scarpa, with its name changed in 2010 to reflect the current leadership under Angela Brooks, FAIA, Lawrence Scarpa, FAIA, and Jeffrey Huber, AIA. The firm is a multi-disciplinary practice that includes architecture, landscape architecture, planning, environmental design, materials research, graphic, furniture and interior design services that produce innovative, sustainable iconic buildings and urban environments with respect for the natural world and fragile ecosystems.

Brooks+Scarpa have garnered international acclaim for the creative use of materials in unique and unexpected ways so as to deliver design excellence that inspires and engages people, incorporating creativity, originality, functionality and technology.

While the Brooks+Scarpa team practices architecture with an extremely rigorous and exacting methodology, it remains open-minded, so that its work can adapt throughout the dynamic process of making places for people. The basis for all Brooks+Scarpa projects is indeed active client participation, resulting in more meaningful and thoughtful buildings, ranging from single-family homes to multi-family housing, affordable housing, commercial, institutional, educational and governmental buildings.

Courtesy of LTL Architects

LTL ARCHITECTS

LTL Architects (Lewis.Tsurumaki.Lewis) is a New York based design intensive architecture firm founded in 1997 by twin brothers Paul Lewis and David J. Lewis, and Marc Tsurumaki. LTL Architects engage a diverse range of work, from large scale academic and cultural buildings to interiors and speculative research projects. Based on the belief that architecture and interior space is the critical site for human social interaction, LTL Architects design carefully choreograph spaces and social relationships to improve and enhance exchanges between people. They realize inventive solutions by turning the very constraints of each project into the design trajectory, exploring opportunistic overlaps between space, program, form, budget and materials.

Over the 23 years of practice, their work has been recognized internationally for synthesizing design excellence and tectonic innovation. The principals are co-authors of the best-selling book *Manual of Section* (2016), which has been translated into German, Korean, Japanese and Taiwanese; monographs, *Intensities* (2013), *Opportunistic Architecture* (2008) and *Pamphlet Architecture 21: Situation Normal...* (1998).

The three principals of LTL Architect are dedicated teachers and are committed to the advancement of the discipline of architecture in contemporary culture. Paul Lewis is Professor and Associate Dean at Princeton University and the current President of the Architectural League of New York. David J. Lewis holds academic positions as Professor at Parsons School of Design and Adjunct Professor of Architecture at the University of Limerick, Ireland. Marc Tsurumaki is an Adjunct Vice Professor at Columbia University, and Associate President of Storefront for Art and Architecture.

Courtesy of Perkins & Will

PERKINS & WILL

The New York studio of Perkins and Will is an 80-person multi-disciplinary design practice focused on a diverse range of project types including commercial, residential, science, healthcare and education work. At the studio's core is a fundamental belief in the power of design: how it defines the spaces where we live, work, learn, heal and discover; expresses the way that we think about ourselves and our communities; and determines how we relate to the natural world around us. The studio has created significant projects for some of the most the most influential organizations in the world, including Cornell University, Memorial-Sloan Kettering Cancer Center, The United Nations, Unilever, Shangri-La Hotels and Columbia Property Trust, as well as numerous collaborations with emerging clients and public institutions. Perkins and Will has been recognized in numerous ways around the world - the NY studio has won over 40 design awards in the last three years, and its work has been shown in exhibitions including at the Center for Architecture in New York and the World Architecture Festival in Barcelona.

Courtesy of sacher.locicero.architects

SACHER.LOCICERO.ARCHITECTS

sacher.locicero.architects is an international collaboration between the French and Austrian architects Eric Locicero and Gerhard Sacher. They founded the studio in Paris and Graz in 1989, but Gerhard and Eric first met in Santiago de Compostela, where they were both winners of the "Europan Competition" in 1989. From this time on, they decided to work together and realized a great number of international projects, which have received numerous awards.

DROO - DA COSTA MAHINDROO ARCHITECTS

© Ula Blocksage, courtesy of DROO
Da Costa Mahindroo Architects

Founded by Michel Da Costa Goncalves and Amrita Mahindroo, DROO - Da Costa Mahindroo Architects are a RIBA and RICS Award-winning practice operating worldwide from offices in London, Paris and Melbourne. DROO take a holistic approach to design with each project being a culmination of the complex network of conditions distilled into a singular poetic statement that valorizes its context - both physical and intellectual.

DROO's projects grow rich from their research focusing on new materials, innovative typologies and advanced modes of design and production. The office builds on its broad experience in design, management and construction. They explore the implications of macroeconomics and emerging technologies on aesthetic and formal undercurrents in contemporary design, and aim to situate this discourse in the environment through tangible, user-oriented design solutions. Each project is at once a tailored solution to the design problem at hand, but also a part of their overarching body of research, which engages the community and is an armature for social and environmental agency.

DROO's work spans through Europe, North America, Australia and South East Asia with a strong research focus on cities and a dedication to developing and promoting architectural creativity to the world. They take part in leading-edge sector events and their work has been recognized by many international awards and published in international magazines. In addition, Michel Da Costa Goncalves and Amrita Mahindroo have been teaching at esteemed architectural schools and bodies across the world since 2004.

MIRALLES TAGLIABUE EMBT

© Paolo Fassoli, courtesy of
Miralles Tagliabue EMBT

Miralles Tagliabue EMBT is an international acknowledged architecture studio founded in 1994 by the association of Enric Miralles (1955-2000) and Benedetta Tagliabue in Barcelona. During their cooperation, Enric and Benedetta started projects like the New Scottish Parliament in Edinburgh, the Utrecht City Hall in Holland, the Headquarters of Gas Natural, the Market and neighborhood of Santa Caterina, their own house in the old city in Barcelona and so on. After the premature death of Enric Miralles in 2000, husband and partner of Benedetta, she continued leading their office, Miralles Tagliabue EMBT as a sole partner, finishing over ten uncompleted works of Enric and starting many new ones. EMBT's mature approach to architecture, interior design, facility planning includes experience with educational, commercial, industrial and residential buildings, restoration of buildings as well as special purpose landscape architecture.

The studio has experience in public spaces and buildings in both Europe and China working for State and Local Governments as well as Corporate and private clients. Today EMBT has offices in Barcelona and Shanghai, and is operating all over the world with a number of new projects in Europe, China, Taiwan, etc. Continuously growing and developing, the working environment is multicultural and full of young aspiring architects working hand in hand with the project directors to produce new innovative ideas and designs. Nonetheless the office has kept its fundamental core: an open approach, full of exploration and experiments together with a high level of conceptual thought. As an acknowledgment of the work done over the years, EMBT has received the Catalan National prize in 2002, RIBA Stirling Prize in 2005, the National Spanish Prize in 2006, City of Barcelona prize in 2005 and 2009, FAD prizes in 2000, 2003 and 2007, and WAF prizes in 2010 and 2011.

MINO CAGGIULA ARCHITECTS

Courtesy of Mino Caggiula Architects

Mino Caggiula Architects is the result of a career path made of planning, designing, building, studying and theoretical research. A well-knit team of architects of different origins and studies that deals with the most varied projects, from designer objects to city planning. Attention to sustainability, context, and territory are the key elements in every single project by architect Mino Caggiula. The main idea springs from the observation of the context and flourishes during the execution phase. This is the transformation of the art form known as Architecture.

The experience acquired down the years has also been enriched by collaborating with theorists and architects such as Kenneth Frampton, Steven Holl, and Elia Zenghelis, who made it possible for the studio to enter the global market and bridge the gap that often exists between Theory and built Architecture.

A•PT ARCHITECTURE - ATELIER PAGNAMENTA TORRIANI

Courtesy of A•PT Architecture
Atelier Pagnamenta Torriani

A•PT Architecture, a New York-based Atelier, is an international practice founded in 1992 by Lorenzo Pagnamenta, AIA and Anna Torriani, AIA. Lorenzo is an expert at the development of sophisticated design geometry and brings an artistic flavor to the studio's projects, having previously been involved in the art world as a painter. Anna's expertise lies in the ability to analyze, synthetize and conceptualize each assignment. She researches the geography, history, interacts with the community and translates the findings into a concept in dialogue with the specific environment. A•PT Architecture's holistic approach to design creates spaces that enrich and engage communities with particular emphasis on local culture and history, original design solutions, and technological acumen.

Sustainability and resiliency are integral aspects of each project from conceptualizing the design to detailing and selecting materials. The studio's projects have been widely published, and their work has been exhibited and presented at the Venice Biennale Collateral Events, the Schusev State Architecture Museum in Moscow, the AIANY Center for Architecture, the Barnard and Columbia Architecture Department, the New Museum and many other venues.

Special Honors include the NYC Public Design Commission exhibition and award for Mariners Harbor Library with Michael Bloomberg; Anna Torriani's nomination by former Secretary General Ban Ki-Moon to serve on the Advisory Board of the United Nations Capital Master Plan; participation to the 2016 Venice Biennale where Shaping Public Space was launched; the inclusion in NYC Design Excellence list for civic architecture.

ABOUT THE PLAN

THE PLAN is one of the most acclaimed architecture and design reviews on the Italian market and, thanks to its strong international approach, is among the most widely distributed and read magazines world-wide.

THE PLAN's editorial philosophy is to provide in-depth understanding of architecture presenting key projects as information and learning tools, which are highly profitable for the professionals who read the magazine. Content quality is a prerequisite.

Each project is prepared with the utmost attention, from the construction details through to images and graphic design.

WWW.THEPLAN.IT

Editor-in-Chief
CARLOTTA ZUCCHINI

Managing Editor
NICOLA LEONARDI

Graphic & Editing
GIANLUCA RAIMONDO

Text Editors
SERENA BABINI
ILARIA MAZZANTI
MATTIA SANTI

Translators
STEPHANIE JOHNSON
ADAM VICTOR

Editorial Staff
ALEXANDRA BERGAMI, LAURA COCURULLO
SILVIA MALOSSINI, SILVIA MONTI

Publisher
PAOLO MAGGIOLI

Maggioli S.p.A.
Via del Carpino, 8 - Santarcangelo di Romagna
www.maggiolieditore.it
E-mail: clienti.editore@maggioli.it

ISBN: 8891633244

Printed in August 2020 on the premises
of Maggioli S.p.A. - Santarcangelo di Romagna